IMAGES
of America

CICERO

6/6/09

To: Jim (DAD) from
Jackie. Happy Fathers DAy

Thomas B. Mafrici

Elizabeth A. Wright

On the cover: This photograph of a World War II Stearman was taken in 1946. This type of airplane was used for crop dusting, aerobatics, and sport flying. The Cicero Airport, where this photograph was taken, was located on the west side of Route 11, three quarters of a mile north of Route 31. It was later renamed Michael Field. (Courtesy of the Cicero town historian.)

IMAGES
of America

CICERO

Thomas B. Mafrici and Elizabeth A. August

ARCADIA
PUBLISHING

Published by Arcadia Publishing
Charleston SC, Chicago IL, Portsmouth NH, San Francisco CA

Printed in the United States of America

Library of Congress Control Number: 2008938750

For all general information contact Arcadia Publishing at:
Telephone 843-853-2070
Fax 843-853-0044
E-mail sales@arcadiapublishing.com
For customer service and orders:
Toll-Free 1-888-313-2665

Visit us on the Internet at www.arcadiapublishing.com

Our thanks our parents, Tom and Natalie Mafrici and Burt and Joan August; our daughters Natalie, Elizabeth, and Madeleine; Lona Flynn; Harold and Inez Baker; Joe Harrington; and the town of Cicero.

CONTENTS

ACKNOWLEDGMENTS

Unless otherwise noted, the photographs in this book came from the archives kept by the Cicero town historian. Nearly all the photographs and documents in the archives were collected by Lona Flynn, who was the Cicero town historian for more than 50 years. Without her hard work and dedication to her job and her town, it would have been impossible to write this book or any book about Cicero. This book also contains many images captured by Clarence Hughson, a longtime Cicero resident and professional photographer. In the mid-20th century, Hughson took many of the best photographs of Cicero. Photographs identified as Hughson's appear in this book thanks to the generosity of his daughter and son-in-law Inez and Harold Baker and the rest of the Hughson family. We would like to thank Larry Baker, who took many fine photographs of the old structures on the four corners just before they were razed in the early 1990s. We would also like to thank Brian Hamilton of the Syracuse Nostalgia blog, who inspired this project. Finally, we would like to thank Arcadia Publishing and specifically our editor, Rebekah Collinsworth, for her invaluable assistance.

INTRODUCTION

For hundreds of years, what is now the intersection of Route 11 and Route 31 has been important to travel in New York. That intersection, known as the "crossroads of New York," is located in the town of Cicero, in the county of Onondaga. The intersection is equidistant to Albany and Buffalo (150 miles) and the Pennsylvania and Canadian borders (90 miles). It is 12 miles to the north of Syracuse. This location has been integral to the development and survival of the town.

For thousands of years, Native Americans lived in the area around what is now Cicero, creating a series of footpaths that later became Route 11. This route begins at the Gulf of Mexico in East New Orleans, Louisiana, and ends in northern New York at the Canadian border. Route 31, one of the longest routes in New York, begins east of Cicero in Vernon, ending near the Canadian border in Niagara Falls. Area residents refer to the intersection of these two roads as the four corners.

The intersection of these two historic roads was also the birthplace of the first plank road in the United States, which ran from Syracuse to Central Square. The first plank was laid in 1846 at the four corners of Cicero in front of the Parker House (later known as King's Hotel). The plank road, which was in operation until 1913, made travel to Syracuse easier, encouraging industry and farming north of that city. The plank road allowed farmers and tradesmen the ability to transport their goods from Cicero to Syracuse and the Erie Canal where the goods could be shipped on to other parts of the state. The road also allowed barrelhead and stave manufacturers and coopers from Brewerton and Cicero to supply barrels for Syracuse's burgeoning salt industry.

Cicero's central location meant that many people traveled through the four corners. As a result, various merchants set up shop near the intersection. Among the first merchants at the four corners were Capt. and Mrs. Isaac Cody, who operated a tavern and store on land they purchased in 1818. For a time, the four corners of Cicero were informally known as Cody's Corners. By the end of the 19th century, the four corners had grown to include to butcher shops, dry goods stores, a hardware store, and a millinery, as well as churches, hotels, and a school. Just outside the four corners, various businesses thrived, relying on the close proximity to the intersection to move their product.

In the mid-1850s, the Cicero stage began to operate using the plank road. The stagecoach traveled from Cicero to Syracuse once a day, carrying people, goods, and mail. For a time during summers, a separate stage operated between Syracuse and South Bay on Oneida Lake in Cicero. Upon arrival at South Bay, passengers could board a steamboat to Frenchman's Island. The Cicero stagecoach was sold a number of times, and in 1909, Daniel Van Alstine, the last stagecoach operator, retired.

Shortly after the dawn of the 20th century, a trolley line was built from Syracuse to Cicero. The trolley, which originally ran 11 miles north from Syracuse to Oneida Lake at South Bay, began operations in 1908. The trolley line owners also owned Frenchman's Island and Dunham Island in Oneida Lake and offered boat excursions to the islands and boat trips around the lake. Hotels at South Bay thrived with the trolley, but almost all of them succumbed to fire before the middle of the century.

In 1912, a trolley line from Cicero to Brewerton began operations, with hopes that the line would eventually extend north to Watertown and the Thousand Island. Both the Cicero and Brewerton lines operated until 1932, carrying mail, high school children, fishermen, revelers, and families to and from Syracuse, Cicero, and Brewerton.

By the 1930s, passenger cars and buses gained in popularity, leading to a drop in riders using the trolley. In January 1932, the last trolley made the trip to Brewerton. The trolley tracks to Cicero were removed, and South Bay Road was built along the track line.

In the mid-20th century, Interstate 81 was built through Cicero, bypassing the four corners and changing the business landscape. While new gasoline stations opened, catering to those driving north or south on the interstate, motels and other businesses that depended on those traveling on Route 11 closed. The new interstate made it easy to travel between Syracuse and Cicero, and many people moved to the suburb. By the dawn of the 21st century, Cicero became one of the fastest-growing towns in Onondaga County. Many housing developments have been built since the 1970s, and one can find almost any fast-food restaurant and large box retailer along Routes 11 and 31. In 1994, old Cicero virtually disappeared overnight when the four corners intersection was improved and widened. As a result, 15 buildings were demolished. With the exception of a few structures, historic Cicero has long been forgotten.

One

THE FOUR CORNERS OF NEW YORK

The four corners intersection in Cicero was not as chaotic 100 years ago as it is today, although it did have its moments. Here a group of steers appears to be strolling, unsupervised, through the intersection. Although undated, the photograph was likely taken in the early 20th century, based on the very early horseless delivery truck. This photograph was taken from the southeast corner looking northwest toward the intersection.

Edwin Shepard began operating a store out of this structure sometime prior to 1900. The building stood on the southwest corner of the Plank Road (Route 11) and Route 31. Shepard's was a general dry goods store. Hattie Shepard can be seen wearing a white apron in this photograph. To the left of Shepard's is the Pritchard home, and to the left of that is Melville Jackson's store, which later became Bitz's. The steps used for boarding and disembarking from the stagecoach can be seen in front of Shepard's.

Some of the Cicero locals are pictured in front of Shepard's store. From left to right are (first row) Cadd Plant, Daddy Townsend, Alex Gault, and George Van Alstine; (second row) Edwin Shepard, Will Bearup, Len Tripp, Nelson Shepard, John Rogers (seated sideways), Frank Coville (Cicero's first druggist), and Elmer Merriam.

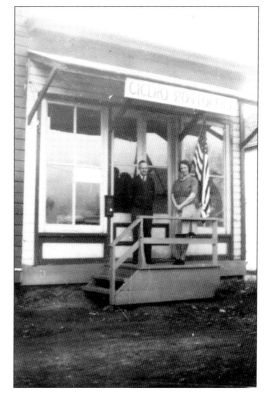

The Route 31 side of Shepard's store was used as the post office. This photograph shows Forest Shepard and Dorothy Mooney. Mooney was appointed postmaster on July 5, 1943, and took over on October 10, 1943. Forest Shepard was appointed clerk in October 1943 and died on January 8, 1944. This building was used as the post office for almost 50 years.

Shepard's store became Teachout's Red and White in the 1940s. Teachout's continued to operate at the four corners for many years.

By the 1970s, the Shepard's store building was significantly altered, and most of its original charm was lost. It was sided, hiding the beautiful quoins. The porch was converted to interior space. The windows were modified, compromising the proportionality. It was razed when the intersection was widened in 1994. Few people realized the historical significance of this structure. (Photograph by Larry Baker.)

This building was the original location for Klosheim's Hardware. In 1851, John Klosheim Sr. arrived in Cicero from Germany and opened a blacksmith shop on the northwest corner of Crabtree Lane and Route 11. In addition, Klosheim operated a hardware store in this building north of the blacksmith shop toward the four corners. The hardware store was later relocated, and this building became Melville Jackson's grocery.

In 1887, Klosheim relocated his hardware store to this building, which he constructed on the northwest corner Route 11 and Crabtree Lane where his blacksmith shop had been.

John Klosheim Sr.'s son John Jr. entered into a partnership with Austin Eggleston in 1919. Eggleston, followed by his son Forest and his grandson Harold, continued to operate the hardware store until the mid-1960s. Here Austin Eggleston stands inside Klosheim's Hardware in 1930.

This photograph of the Klosheim's Hardware building and the Klosheim residence was taken in 1966. John Klosheim Jr.'s son Harold became a prominent attorney. In addition to working for the attorney general for nearly 30 years, Harold Klosheim was also the Cicero town justice for eight years. He occupied the house from his birth until 1967.

The Klosheim family occupied the northwest corner of Crabtree Lane and Route 11 for over 100 years. In 1968, the site was then redeveloped. The Klosheim residence was relocated around the corner and can be found at 5775 New Street. The hardware store was destroyed. An Atlantic gasoline station was built on the property.

Here is Bitz's store in 1939. Melville Jackson opened a butchery and grocery store in the building vacated by John Klosheim Sr. after he built his new hardware store in 1887. At some point after 1900, Clarence Bitz took over the business from Jackson, his father-in-law. Later the store was known as House's Superette. This photograph shows the Cicero Union School to the left. At the time, it was being used as the Independent Order of Odd Fellows temple. Note the early fuel truck.

Clarence Bitz (left) and Fred House are standing in front of Bitz's store. To the right is the home of Roscoe and Anna Bitz. For several years, Clarence Bitz and his brother Roscoe were partners in the store. Later the House family lived on the top floor of the house.

This photograph was taken in 1931 inside Bitz's store. From left to right are Fred House, Virginia Smith, and Roscoe Bitz. Surprisingly, fresh pineapples and other delicacies could be purchased in Cicero during the Depression.

Clarence Bitz and Fred House are inside Bitz's store. In 1921, House began working for Clarence Bitz. In 1945, House took over the business, and Bitz continued to work for House for an additional 15 years before retiring in 1960. The store eventually became known as House's Superette. It specialized in meat processing, and at its height, it employed 10 meat cutters.

By the early 1900s, the building that had been Bitz's store and House's Superette became known as New York Bottle Return. By that time the home next door had been converted into retail space (photographed below). The bottle return was operated by Harry Crowell, a former butcher at House's Superette. Like the other buildings at the four corners, years of remodeling had stripped the Victorian detail from these structures. They were razed in 1994, and few took notice of their destruction. (Photographs by Larry Baker.)

In 1880, Frank Coville and Seward Snow bought this house on the southeast corner of the four corners and converted it to a drugstore. It contained 900 square feet of store space. Alfred E. Davey purchased the store from Coville in 1911. Davey, along with his son Floyd, pictured below, continued to operate a drugstore out of this structure until 1939. Floyd Davey also played piano and gave lessons to the locals.

Jack Paulus rented the pharmacy from Richard Davey, Floyd Davey's son, starting in 1939. The rent was $50 per month. By that time, a gasoline station and diner had been added to the north side of the structure. Paulus apprenticed for a Syracuse druggist from 1924 to 1928. As this was during Prohibition, that pharmacy procured medicinal alcohol, diluted it greatly, and sold it to thirsty customers.

Paulus rented the pharmacy for nine years before purchasing it in 1948. He tore down the old pharmacy in 1951 and opened this modern pharmacy in 1952, complete with a soda fountain and a bomb shelter. Legend has it that Paulus kept the fishing bait right next to the ice cream. Paulus operated the pharmacy until the 1990s, although he did not keep regular hours and was rarely open for the last 20 years of operation. The pharmacy was razed in 1994 when Route 11 was widened.

The home of Arthur Stearns was located near the southeast corner of the four corners. Stearns was appointed postmaster of Cicero in 1898. He and his wife were very active in community affairs. Stearns died in 1945, and in 1948, Catherine Paulus, the wife of the druggist, purchased the home. Paulus owned the property for many years, and the once-stately house finally deteriorated. Most considered it an eyesore when it was demolished in 1999. Thomas Mafrici Sr. purchased the empty lot in 2000, and it became incorporated into the parking lot for Frank's Plank Road Café.

In January 1852, the town records were lost in a fire at the store of C. Carr and Sons, which stood on the northeast corner of the four corners at Route 11 and Route 31. Capt. Charles H. Carr, a retired sea captain, replaced his destroyed store with this brick structure in 1854.

Irving Coonley operated a general store in the building for many years, beginning around 1880. He served as postmaster for 18 years and also as a justice of the peace. Freddie Fisher, pictured above, delivered baked goods to Coonley's store once a week from a bakery in Syracuse. Note the campaign photographs of William Taft and John Sherman, which places the date of this photograph at 1908.

The Coonley family lived in this house on the north side of Route 31 east of Coonley's store. It stood to the left of the former Reformed Church (later the Grange hall). From left to right are Mabel Coonley, Howard Coonley, Irving Coonley, Mrs. Cahill and her daughter, and Ace Smith. The baby being held by Mrs. Howard Coonley is most likely Alice Coonley, born in 1906. She married Earle J. Machold, president of Niagara Mohawk.

Hiram Sayles took over the store from Howard Coonley in 1924 and operated a general store at this location for many years. He lived in the annex on the left side from 1924 until the mid-1980s. This photograph is from 1939.

By 1990, the building was being used by Affordable Flowers, the last occupant. In 1994, it was razed when the intersection was widened. By this time, the building was barely recognizable. The brick had been covered with stucco and stone appliqué. (Photograph by Larry Baker.)

Local war hero and respected politician Asa Eastwood (1781–1870) and his youngest son, Enos, erected what was long known as the old yellow store, which, after the Eastwoods, was kept by Julius Dunham, Allen Merriam, Irving Coonley, Horace D. Parks, and James Van Alstine, according to Dwight H. Bruce's *Onondaga's Centennial*, 1896. Located on the northeast corner of Route 11 and Crabtree Lane, this building burned down in a large fire around 1922. Cadd Plant's Cicero Food Mart was built on the site.

CICERO FOOD MART & U.S. POST OFFICE ~ CICERO, N.Y.

Cadd Plant worked for Edwin Shepard for many years before becoming a partner at Shepard and Plant. Soon after, Plant opened the Cicero Food Mart on the northeast corner of Crabtree Lane and Route 11 in the 1930s. In the 1970s and 1980s, the Record Shed was operated out of this site. The Record Shed, owned by Robert Ravas, was as popular place to buy records.

Cadd Plant was born in 1885 and died in 1972. His wife, Alice, pictured with him here, was born in 1884 and died in 1964. In 1967, AAA awarded him with the 50-year membership award. He had purchased a brand-new Model T Ford in 1915.

This photograph of Alice and Cadd Plant in front of the Cicero Food Mart was taken around 1940. His ancestors were among Cicero's first settlers, having arrived in 1833. Plant worked in sales his entire life. He was widely known for his ability to instantly add up large columns of numbers in his head. (Photograph by Clarence Hughson.)

For a number of years, the post office was located in the building attached to the left side of the Cicero Food Mart. Cadd Plant served as postmaster from 1932 to 1943. He operated Cicero Food Mart until the late 1960s.

B. J. Flynn's meat market stood on the southeast corner of the intersection of Crabtree Lane and Route 11. The building had meeting rooms upstairs where the Odd Fellows and Rebekahs met prior to purchasing the Cicero Union School in 1922. The meat market building was razed in 1994 when the intersection was widened.

Here are Charlie King (left) and F. Hale (a coproprietor of the Trolley barbershop) pretending to saw wood in front of Flynn's meat market. There is now a parking lot where the meat market building once stood. The Cicero Food Mart is in the background on the north side of Crabtree Lane.

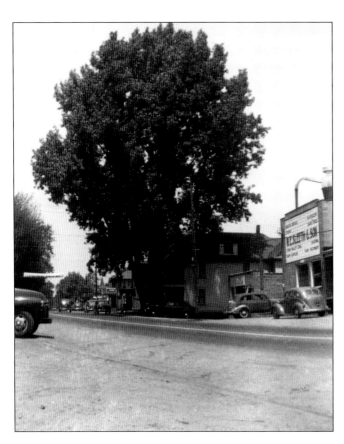

This huge tree stood on the east side of Route 11 just south of the intersection with Crabtree Lane. This photograph from the 1940s, looking north, shows Sleeth's feed mill to the extreme right.

This picture of Flynn's meat market building was taken a few years before the building was razed when the intersection was widened in 1994. (Photograph by Larry Baker.)

This photograph of Przytula's pig farm and junkyard was taken around 1940 from the northeast corner of Route 31 and Crabtree Lane. King's Hotel is visible to the right. Eventually, pig farming was discontinued while the junkyard operated until Stosh Przytula's death in 2007.

What became Sleeth's feed mill was started by George Albert Down Sr. The building was originally located on the northwest side of the four corners where the firehouse was later built. In 1910, Downs moved the building to the east side of Route 11 just south of Crabtree Lane and north of Mud Creek. Walter Sleeth, a horse trader, purchased the feed mill in 1922. This photograph from the 1930s shows Sleeth on the steps.

This picture of Lyle Hawthorne inside Sleeth's feed mill was taken in 1930. Walter Sleeth owned a farm with a brick house at 8765 Route 11, located about one mile north of the four corners. He later moved to North Syracuse. Sleeth served as the president of Cicero State Bank for many years. He was also the supervisor for the Town of Clay for 18 years.

Robert Sleeth became partners with his father in 1937. In 1938, the original building was moved to the back of the lot and replaced by this cinder block structure. In the late 1940s, Robert Sleeth became a GMC truck dealer and later acquired an Oldsmobile franchise. In this 1940 photograph, the Trolley barbershop is still visible to the left.

By 1964, Robert Sleeth moved the Oldsmobile dealership to North Syracuse, at which time the feed mill closed. In 1974, the property was leased to Cicero Valley Electric, which operated out of that building for many years. This photograph of the feed mill building was taken in 1986. The building was torn down when Route 11 was widened in 1994. (Photograph by Larry Baker.)

The blacksmith shop of Phelan Pallas was located to the south of the feed mill and north of Mud Creek. It was purchased by Robert Sleeth and incorporated into the feed mill. Robert Sleeth began to shift away from the feed business and focus on automobile and truck sales, and the building was razed in 1959.

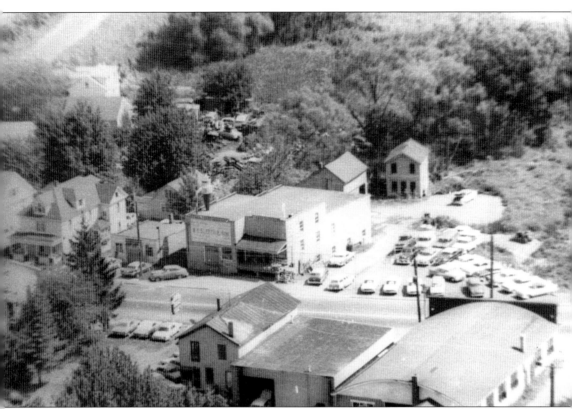

This is a rare aerial view of the Sleeth properties. In the foreground is the back of the old Cicero State Bank. By this time, it was connected to the old Ford garage building. These buildings were used by Sleeth Oldsmobile for automobile service. Across the street from the extreme left is part of Dr. William Serog's dentist office. To the right is the Keegan residence followed by a cinder block garage and Sleeth's feed mill buildings. Note the cars for sale to the right of the feed mill. Stosh's junkyard can be seen at the top. Of all these structures on Route 11, only Serog's and the little cinder block garage remain today.

The Cicero Mills Company was formed in 1871 by a number of Cicero's leading citizens. The original stockholders were farmers from the area, but eventually Addison J. Loomis acquired most of the shares. It was a multiuse milling and manufacturing facility and was located on the west side of Route 11 just south of Mud Creek. It contained a flour mill that ground 50,000 pounds of flour per year by means of two revolving stones that were about five feet across. It also contained a sawmill that cut about 800,000 feet of lumber per year. There was an upright saw for lumber and circular saws for lathe. Finally, a stave mill produced about two million staves per year that were essential for salt production. The mill employed about 20 workers. It burned in 1896.

The Cicero Canning Factory was owned by Addison J. Loomis and George and Loomis Allen. It was located on the west side of Route 11 (near 8279 Route 11). In 1878, the factory produced 300,000 cans of corn. The factory operated under various owners until at least 1923. The two wooden buildings were moved and reused as apartment buildings. The brick building that housed the boilers is still standing.

The Loomis Cheese Factory was built in 1855 by Addison J. Loomis. It was located one mile north of the four corners on the southeast corner of Route 11 and McKinley Road. The factory used the milk from his 100 dairy cows and 400 other cows and produced 150,000 pounds of cheese annually. He also owned and operated a cider mill near this facility.

Chester Loomis (1785–1851) was a pioneering settler of Central Square, where he operated a tavern. In 1823, he purchased the house pictured above, which was built about 1807. It is still standing on the east side of Route 11 one mile north of the four corners. From this location, he operated a tavern and raised 12 children. One day he "got religion," dumped out the whiskey barrels, and renamed his establishment Temperance Inn.

Addison J. Loomis was the most successful of the Loomis children. He became the largest farmer in Cicero and owned 300 acres of land. He built this Victorian home around 1875 just south of his father's home, approximately one mile north of the four corners on Route 11. Loomis was the principal owner of Cicero Mills Company, was partner in the Loomis and Allen Canning Factory, and served as Cicero town supervisor. The Loomis family was friends with Melvil Dewey, creator of the Dewey decimal system. Dewey visited the residence when passing through on his way north to his hometown of Adams Center or to the Adirondacks.

Fred Potter married Loomis's daughter Franc and took over the homestead and farming operations. The farm was successively operated by Potter's son Ed and his son Robert. The dairy farm was continued until the 1950s when much of the acreage became cut off by the construction of Interstate 81. The campanile tower and the porch of the family home were removed in the 1920s. Ed Potter's widow, Arlene, lived there until the late 1980s. The house stood vacant for over five years and was in a state of advanced deterioration. It was restored beginning in 1994, and the tower was subsequently rebuilt.

The Moyer Carriage Factory was located on the corner of Route 11 and New Street on the north side of Mud Creek. H. A. Moyer built fine carriages, operating out of this building from 1876 to 1881. He employed 30 workers. A thousand wagons per year were produced at this facility.

H. A. Moyer Factories, Syracuse, N. Y.

Moyer later built a carriage factory and automobile factory in Syracuse near the corner of Hiawatha Boulevard and Salina Street. The large brick building is a landmark, known for having a "house" on the roof. Moyer built automobiles from 1910 to 1915. At his peak, he employed over 600 workers at this factory.

The sign on this building reads, "B. B. Andrews, Horse Shoeing and General Blacksmithing." The shop stood near the southwest corner of the intersection of Route 31 and Route 11. The belfry of the Cicero Union School is visible in the background. The house to the left was once occupied by Roscoe and Anna Bitz.

This structure, built in the 1860s, was located on the south side of Route 31 between Route 11 and Crabtree Lane. Peter and Mabel Deitz purchased it in 1917, and it remained in the family until the 1980s. Harold Jaquay and Leona (Deitz) Jaquay occupied the house and also operated an insurance business in the building. The building was razed in 2000, and the gasoline pumps for Byrne Dairy were placed on this site.

This home is located at 8380 Route 11 just north of the four corners. It was the first house north of Coonley's store and has been in the same family for over 100 years.

The Cushing name had been prominent in Cicero since the pioneer days. This house at 8261 Route 11 was occupied by Eugene Ward and Rosetta (Loomis) Ward, daughter of Addison J. Loomis. Currently it is known as William's Funeral Home. Richard Williams is the only businessman left from old Cicero when it still resembled a village.

The P. J. Van Hoesen residence and cigar factory was located on the south side of Route 31 near the intersection with Crabtree Lane where the Red Apple convenience store is now located. Cigars were manufactured in the garage behind the house pictured below using locally grown tobacco from Clay (Cigarville) until the death of Van Hoesen in 1930. The house was subsequently occupied by Clarence Hughson (1906–1991), a part-time photographer who took many of the best pictures of historic Cicero. (Photographs by Clarence Hughson.)

Dr. Hezekiah Joslyn, an abolitionist, came to Cicero and opened his medical practice in 1823. He married Helen Leslie in 1825 and built this house. The house was located on the west side of Route 11 about one half mile north of Route 31. For many years, Joslyn was the principal physician in town. He was a founding member of the radical abolitionist Liberty Party, and this home was used as a station on the Underground Railroad. He later moved his medical practice to Syracuse and sold the house. The Joslyns' daughter Matilda Joslyn Gage was an avid proponent of women's rights and worked with Elizabeth Cady Stanton and Susan B. Anthony to secure women's right to vote.

The Pardee family has a long history in Cicero. The Pardee farm was located on Route 31 about a quarter mile east of Route 11. Stanley Pardee was a cattle dealer and a director of Cicero State Bank. These photographs show the homestead on the north side of Route 31 and a hay baler used on the farm. Much of the farmland bordering Route 31 and Pardee Road was sold off and developed in the 1980s and 1990s.

The Cicero Cheese Factory stood on the south corner of Factory Street near the intersection with Route 11. It was the last cheese factory to operate in Onondaga County. Cheese was made continuously in this building from 1880 to 1979. Frank Buckley made cheese at the site for almost 20 years and was said to be an authority on cheddar.

Frank Esposito purchased the cheese factory from Buckley and made cheese for many years. After his death, his daughter Carmel, her husband Ralph Parlato, and his uncle Maggiorino Parloto continued to make fine Italian ricotta and mozzarella cheeses. This photograph from July 11, 1968, shows from left to right Magiorino Parlato, Charles Flannigan, Ralph Parlato, and unidentified.

This gasoline station was located near the southeast corner of the four corners. It stood to the north of Wright's Hotel. This structure was still standing until 1983. In later years, it was used as an antique store. Today the site is part of the parking lot for Frank's Plank Road Café.

CICERO, NEW YORK
ROUTE 11 & JAMES ST.
CO-66
AUTH. NO. 2303

This gasoline station was located on the northwest corner of Route 11 and Crabtree Lane. It was built in 1967 on the site of Klosheim's Hardware store. The gasoline station was closed in 1968 after 2,000 to 3,000 gallons of high-test gasoline leaked out of the tank and imperiled the whole town. The leak was so extensive that gasoline was found in the basements of buildings across the street. The residents of three buildings were forced to evacuate, and it took at least two days to pump out all the gasoline. This building housed Cicero Discount Liquors for many years until it closed in 2006.

For many years, Hines gasoline station was located on the northwest corner of the four corners. The Hines family lived on Route 31 adjacent to the gasoline station. The property came to be known as Hines' Corners to the locals. This gasoline station was razed in 1980.

Baker Garage was originally located on the corner of Route 31 and Burnet Road in the town of Clay. In the 1930s, Howard Baker built this garage at 8279 Route 11 where he repaired cars and sold new and used cars. Today the structure exists, with numerous additions, as North Syracuse Lawn and Tractor. (Photograph by Clarence Hughson.)

The Ford garage was adjacent to the structure known at various times as the Cicero State Bank and Bonstead Hotel (visible on the extreme right). It was later purchased by Robert Sleeth, and a structure was built connecting the garage to the old hotel/bank building. These buildings were used as part of the Sleeth Oldsmobile GMC Truck complex. Both structures burned in 1968.

This location on the corner of Route 31 and Thompson Road has been the site of a gasoline station for at least 70 years. The Shell station in this 1937 photograph was owned by Garry Hammond. For many years, it was the site of a Rotary gasoline station. It is currently the site of a Kwik Fill gasoline station.

Plummers Sunoco service station was located at 9628 Route 11 in Brewerton. There were fewer gasoline stations to choose from in Brewerton as opposed to nearby Cicero where they appeared on every corner.

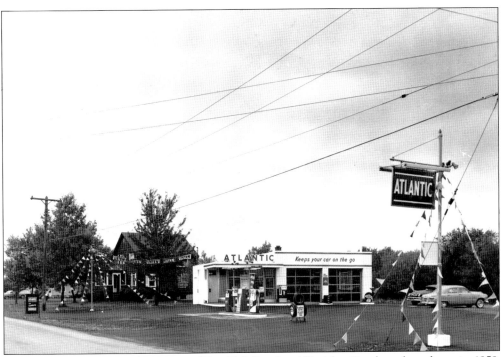

This Atlantic station on the corner of East Taft Road and Kreisher Road was brand new in 1959. The building still exists, although it bears little resemblance to its original appearance.

The caption on this 1958 photograph states that this Atlantic station was located on the corner of Route 31 and South Bay Road. However, there never was a gasoline station at that intersection. In fact, it was located on the corner of Route 31 and Lakeshore Road and operated by Emil Henry. This site later became Larry's Fish Fry and then Dunkin Donuts.

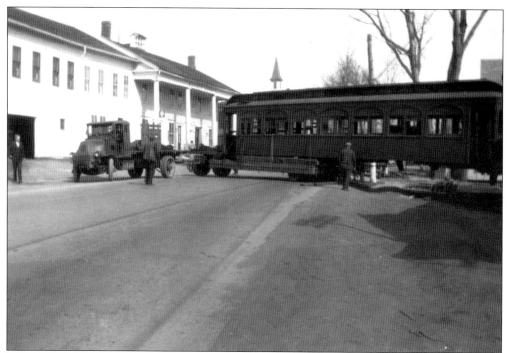

After the trolley line was discontinued in 1932, many of the trolley cars were purchased to be used as seasonal camps along Oneida Lake. One of the trolley cars was used as a barbershop. The Trolley barbershop was located on Route 11 north of Mud Creek adjacent to Sleeth's feed store. It was owned by F. Hale and Hank Dirnhofer. These photographs show the trolley being delivered to its site by a vintage Mack truck with the King's Hotel in the background.

Joe Corso operated many bars and restaurants on Route 11 in Cicero. Among them were the Deck Lounge, the Roman Eye, Close Encounters, the Sports Page, and La Bella Vin. The exterior and interior of the Deck Lounge are pictured here. The Deck Lounge was located at 8037 Route 11 just south of where Target is now.

Many Cicero residents have fond memories of the Sports Page, home of the 99¢ lunch. The Sports Page was located on the east side of Route 11 just north of Caughdenoy Road and closed in the 1990s. The building was abandoned and sits ready for redevelopment. After it closed, Joe Corso opened La Bella Vin in the building fondly remembered as Paul's English Pub and Bakery, which is north on Route 11. La Bella Vin closed and became Nino's Sports Bar.

The Sports Page building was known by other names over the years, including the Batchelor III. Originally, it was known as the Colonial Drive-in (pictured here). The overhangs that kept the cars dry at the drive-in were later adaptively reused to keep golfers dry at the Cicero Driving Range. The driving range sits on the west side of Route 11 one half mile north of the four corners.

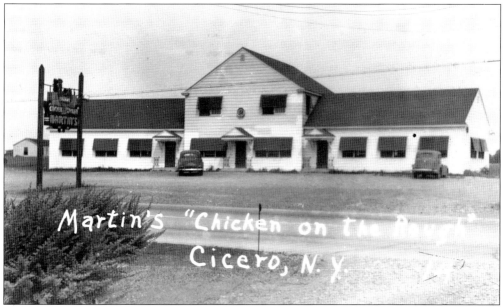

Martin's Restaurant was a very popular establishment. Built by Thomas J. Martin, it was located on the east side of Route 11 near where Wegmans is now located. It opened in 1942 and was famous for its "chicken on the rough." It was destroyed by fire in 1971 a month after it was purchased by Mitchell Shulman and never reopened. (Photograph by Clarence Hughson.)

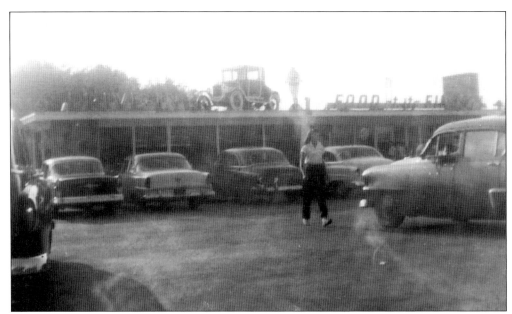

Along with the Colonial Drive-in, Fred Cianilli and Carl Breman built and operated the Country Squire, which stood on the west side of Route 11 just south of Caughdenoy Road. This building was later known as Close Encounters. Cianilli purchased the Model T inexpensively, and when it stopped running, he put it on the roof. The large outdoor menu existed for many years until the site was redeveloped in the 1990s.

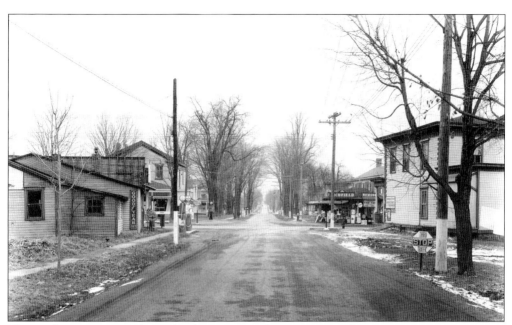

This is the view approaching the four corners if one were traveling east on Route 31. Hines gasoline station is on the left. Also on the left past the intersection is Coonley's store, by this time known as H. H. Sayles General Store. On the right is Shepard's store and Crossett's Service Station. Davey's drugstore can also be spotted past the intersection. None of the buildings in this photograph remain standing.

This is a view of Route 31 looking west toward the four corners around 1992. The three structures in this photograph were razed when the intersection was widened. The house on the left was Robert Ravas's video store. It became a parking area on the right side of the Byrne Dairy. The next house and Paulus's pharmacy became parking lots for Frank's Plank Road Café.

Driving north toward the four corners, trees line the edge of Route 11 in front of the Klosheim residence near the intersection with Crabtree Lane. On the left side, Bitz's store is visible. On the right side, the turreted house later became part of the parking lot for Frank's Plank Road Café. Wright's Hotel is to the right of the turreted house. The little building to the right of Wright's Hotel is still standing.

This photograph captures a view of the four corners driving south on Route 11 in the 1930s. Starting on the left are H. H. Sayles (formerly Coonley's) store, Crossett's fish fry and gas station, Davey's drugstore, the turreted house, Wright's Hotel, Cicero Food Mart and Flynn's meat market, Smiley's Ford Garage, Cicero State Bank, Klosheim's hardware store and residence, the Universalist church, Bitz's store and residence, Shepard and Plant's store, and Hind's garage.

Two

HOTELS AT
THE FOUR CORNERS

This photograph shows a parade in front of King's Hotel, the oldest and most famous hotel and tavern in Cicero. The hotel was located on the west side of Route 11 on the south corner of Crabtree Lane. It was originally known as the Parker House and subsequently became King's Hotel years after Charles King purchased it. The first plank for the plank road was laid in front of this building. Capt. Isaac Cody built the first tavern in Cicero shortly after his arrival in 1818. That tavern building later became part of King's Hotel.

Parker House. Cicero, N.Y.

These photographs of the Parker House are both undated; however, because the sign in each says, "Parker House, Chas. J. King, Proprietor," they could not have been taken earlier than 1895, the year Charles King purchased the hotel. In the above photograph looking north, Klosheim's Hardware store is visible across Crabtree Lane, as is the steeple of the Universalist church. The photograph below, looking south, shows the Webster House (formerly known as the Bonstead Hotel, then Hart's Hotel, and later Cicero State Bank) to the south of the Parker House. Although King purchased the hotel in 1895, the Parker House was not renamed King's Hotel until around 1920.

CICERO, N.Y.

King was born in Liverpool, New York, in 1877. He was a barber by trade in Liverpool for several years before opening a barbershop in the Parker House. After two years cutting hair in the Parker House, King went back to business in Liverpool. However, in 1895, he returned to Cicero and purchased the hotel. King was a popular hotel man. By all accounts, he was known for his gregarious personality.

This is an undated photograph from in front of King's Hotel. From left to right are Peter Dietz, William Cushing, Peter Lawton, Charles King, and ? Bamerick. Dietz lived in a house on Route 31 that was torn down to make way for the Byrne Dairy gasoline pumps. The Cushing family was among the earliest settlers in Cicero. They were longtime owners of King's Hotel when it was known as the Parker House.

Charles King (right) is with Al Smith (left) and Peter "Bill" Herbrandt (center). Herbrandt worked at the hotel from 1905 until 1944. After King died in 1936, Herbrandt married his widow, Hattie.

This photograph of the front desk of the King's Hotel was taken in 1930. King is on the left, and Herbrandt is in the middle. Note the Cicero State Bank calendar on the left.

Before 1918, it was popular for people from Syracuse to drive to Cicero in their carriage or automobile to eat chicken dinner at King's Hotel. According to an article in the *Syracuse Herald* on December 15, 1918, "Cicero was then entirely surrounded by toll gates and you had to pay three cents every little while to get there. But people considered it worth the price." Up to 150 automobiles an hour traveled past King's Hotel on a "pleasant Sunday," and the cars in front of King's Hotel made it look "like Vanderbilt Square, but different." However, by the time that article was published, Cicero had passed a law prohibiting the sale of alcohol. In response, King went south for the winter and closed King's Hotel. Wright's Hotel also closed, leaving Cicero residents with nothing to do and nowhere to go. These photographs show that at some point in the late 1920s, the second-floor balcony of the hotel was removed.

Charles and Hattie King are on the porch of King's Hotel in this undated photograph. Hattie King continued to operate the hotel for eight years after her husband died. It was then sold to Roy Oelschlager, who operated the hotel for the next two decades.

Charles King is pictured here behind the front desk of King's Hotel in June 1936. He was proprietor of the Parker House/King's Hotel for 41 years. By the time of this picture, both of his legs were amputated due to diabetes, but King managed to get around on two artificial limbs. He died less than three months after this picture was taken.

In 1944, Oelschlager purchased King's Hotel from Hattie King, widow of Charles King. This picture of Oelschlager and his wife was taken in 1950. Oelschlager operated the hotel for almost 20 years. During this time, the property gradually deteriorated. The kitchen, hotel, and diner eventually closed, and only the bar remained open. The bank eventually foreclosed on the property. An auction was held, and the assets of the hotel were sold to the highest bidder.

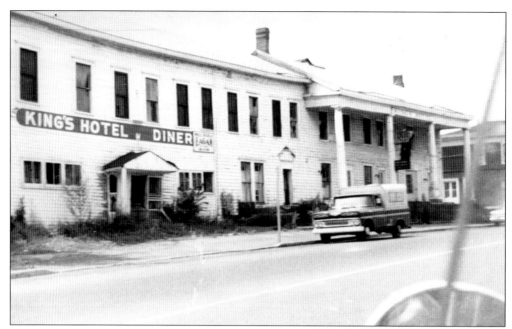

The King's Hotel is pictured during its last days where it had been abandoned and vandalized for several years. The hotel and its contents were auctioned off in 1963, and the building was purchased by George Smutz, who had recently developed the Expressway Lanes bowling center. According to Millard Rogers, the town supervisor at the time, the old building "created a serious fire problem and safety hazard since closing." In one form or another, the building had been a hotel since Isaac Cody opened his tavern in 1818. The once-proud building was razed in 1965, and an A&P grocery store was built on the site. The grocery store closed in the 1990s.

Rogers was correct in calling King's Hotel a fire problem. In December 1964, a small fire started in cushions at the vacant hotel. The fire was quickly put out without causing any major damage. By that time, the hotel had become an eyesore, and Smutz had it demolished in July 1965. For over 100 years, the hotel catered to the hungry and tired who traveled through Cicero. It had also provided the residents of Cicero with entertainment, dining, and a place to celebrate weddings and other occasions. The demolition of the building marked the end of an era for historic Cicero.

This miniature version of King's Hotel was on the top of the hotel since the 1800s. It was saved when the building was razed. Legend has it that it was being repaired by a town employee but then disappeared. Perhaps it is still in someone's basement or workshop.

This hotel was built in 1825 on the northwest corner of Routes 11 and 31. In 1874, it was purchased by William Lester Herrick. Herrick was a schoolteacher in Clay before enlisting with the Union army in 1860 where he served as a captain. He was captured by the Confederates and held as a prisoner for a year at Libby Prison. When he was released from captivity, Herrick weighed less than 100 pounds, and his health never fully recovered. He died at the age of 38 in 1877.

Herrick's widow continued to operate the hotel and tavern for five years after he died. In 1882, the contents of the Herrick House were auctioned off, and the hotel was ultimately purchased but burned down in 1887. Herrick's son William purchased the Cicero stage line in 1895 and operated it for almost 10 years.

This structure was known by many names over the years. It stood on Route 11 just south of King's Hotel in the approximate location of Meineke Muffler. It was originally known as Hart's Hotel. It was later named Webster House, Bonstead Hotel, and Cicero State Bank, and it was finally part of the Sleeth Oldsmobile dealership before burning down in 1968.

This photograph of the Bonstead Hotel was taken looking north on Route 11. King's Hotel is visible on the right, as is the steeple of the Universalist church. The sign on the wagon in front reads, "John S. Tilley Watervliet, N.Y. Ladders, Stepladders, etc."

From 1926 until the early 1950s, the old hotel building served as the Cicero State Bank. The security system consisted of placing the safe in the front window with a lightbulb hanging over it. The back of the building was occupied by two families.

The back of the Cicero State Bank was used by tenants. Pete and Mina Zinsmeyer lived upstairs during the 1940s. (Photograph by Clarence Hughson.)

By 1953, the Cicero State Bank had outgrown its home in the old Bonstead Hotel and built this new facility at 8304 Brewerton Road. It was purchased by Merchant's Bank in 1960, and a drive-through window was added in 1967. In 1968, the bank was held up, and $38,000 was taken. It was the first time a Merchants Bank branch was held up in the bank's 118-year history. In 1985, the drive-up teller was held up, and $3,000 was taken. In each case, the suspects were arrested within 24 hours of the robbery. It was renamed OnBank in 1993 and became M&T Bank in 1998.

Fred Muckey's Cottage Hotel was located near the southeast corner of Routes 11 and 31. This photograph is from 1907. The hotel was later known as Wright's Hotel, Shay's Tavern, Garvey's Tavern, the Rum Runner, and Frank's Place. It burned down in 1994. Frank's Plank Road Café was built upon the foundations of the original structure, and the floor joists are still visible in the basement.

At the dawn of the 20th century, most of the towns in central New York had their own brass band. The Cicero brass band held concerts on Saturday and Sunday nights. Here the Cicero band was photographed along with a few locals in front of the Cottage Hotel. The Cottage Hotel later became Wright's Hotel.

The Cicero Center Band, photographed here, attended the Cicero firemen's picnic and convention in 1903. A few of the members were from Central Square. Many bands of that era wore military-inspired uniforms like the ones pictured here. The members in this photograph are J. G. Hotaling, James Moss, Will Moss, George Revoir, Dr. Ed Hall, Harry Strong, R. E. Tuttle, Ad Hall, Gain Wells, Marshall Higley, Frank Czarkowski, Dave Johnson, Charles Sadler, William Van Alstine, S. K. Button, and Bert Muckey. This photograph was taken in front of the Cottage Hotel.

A fire caused serious damage to Wright's Hotel in 1935. According to an article in the *Syracuse Herald*, "the business section of the Village of Cicero was menaced early Thursday by a fire that virtually destroyed Wright's Hotel." The 50-year-old hotel was rebuilt.

This picture of Wright's Hotel (formerly Fred Muckey's Cottage Hotel) was taken in 1923. The little building on the right still exists at 8356 Route 11 and is used as the offices for Frank's Plank Road Café. For many years, it was used as a barbershop. The photograph below was taken in 1995.

Three

RELIGIOUS LIFE

The Universalist church was located on the west side of Route 11 to the left of the Cicero Union School. It was built in 1832. This photograph is from the 1800s. Later the building was modified. The entire structure was raised, a basement was created, and steps were added in the front. In addition, a large semicircular window was installed over the front doors. Finally, the fencework around the steeple was removed.

The Universalist church was razed in 1960 to make way for the new post office that was built on the site. In the 1990s, the post office was moved to a new building on Route 31, and the original structure was sold to Al Caza Contractors, which still occupies the site.

This picture is of the original Sacred Heart Church that was built in 1889 on New Street. In 1964, the congregation moved to a new building on Route 11. The original building was later occupied by Wicker World.

The Cicero Methodist Church was built in 1851 north of the four corners on the east side of Route 11. This church was replaced by a more modern structure in 1963.

The Reformed Church of Cicero building was constructed in 1836 on the north side of Route 31 between Route 11 and Interstate 81. The original building burned in 1882 and was replaced with the one in this photograph.

By 1924, less than 30 members of the Reformed Church of Cicero remained. The congregation disbanded, and the building was sold to the Grange. The parsonage was sold to Mr. and Mrs. Vern A. Chandler. Upon the sale, most of the remaining members joined the Methodist Church. The Grange was demolished in 1966 to make room for a Texaco gasoline station.

Four

TRANSPORTATION FROM STAGECOACH TO HIGHWAY

The first plank road in the United States was built in New York in 1846. The one-lane plank road ran from Central Square to Syracuse, with southbound traffic using the plank road and northbound traffic running on the dirt road. The first public transportation in Cicero was the stagecoach. From 1854 until 1909, the Cicero stagecoach operated between Cicero and Syracuse over the plank road. In addition to carrying passengers, the stage also carried the mail. Daniel Van Alstine, pictured here, was the last operator of the stage line and made the final run on February 27, 1909. It was reputedly the last stagecoach line to run in America.

The above picture of the Snowbird winter stagecoach was taken in front of the Parker House in 1909. Note the sign above the drivers reads, "Parker House, Chas. J. King, Proprietor." The name of the hotel was not changed to King's Hotel until about 1916. The summer stage idles in front of the Parker House in the undated photograph below. The structure in the background to the right was known as the town barn, where the town stored its equipment.

Because of the snowy winters in central New York, a separate stagecoach was equipped with rails for the winter. These photographs of the Snowbird were taken at the downtown Syracuse headquarters for the stage. The building with the pump advertisement still exists and is known as 123 Willow Street.

This house and barn was the home of the Cicero stage and the owner. William Herrick purchased this property along with the summer and winter stages from former stagecoach owner and operator William Petrie in 1895. It was located on Route 31 where the Red Apple convenience store is now located. The house was moved to McKinley Road, and the barn was razed during the construction of Interstate 81. (Photograph by Clarence Hughson.)

Pictured from left to right in this 1897 studio photograph are (first row) Charles King and William Herrick; (second row) William Cushing and Frank Moulton. In addition to his stagecoach business, Herrick served as the town supervisor for four years and as a state assemblyman in 1900.

After 18 years of operation, Petrie sold the Cicero stage line to Herrick in 1895 for $2,800. This price included the house and lot, barn (pictured above and below), summer and winter stages, and horses. Herrick operated the line until 1903 before selling the stage. He retained the house and barn when he sold the stage line and continued to live on the property until he died in 1958 at the age of 91. The interior of the barn contained many wonderful lithographed posters of local stage productions from the 19th century.

Long ago, someone inscribed "Cheerful Idiot" on the back of this photograph. This photograph represents one of the earliest images of the four corners. The man is sitting on the old stagecoach steps that stood in front of Shepard's store on the southwest part of the four corners. Coonley's store appears at the rear left on the northeast part of the four corners.

The Cicero stage is photographed here in front of the Volmer store on the corner of Route 11 and Church Street in North Syracuse. Daniel Van Alstine is the driver. The bicycle in the back foreshadows a time in the near future when the stage would no longer be needed.

The following was written on the back of this postcard: "I thought you would like a picture of the Cicero Stage, It will soon be a thing of the past."

Long after the automobile supplanted the stagecoach, elderly former stagecoach operator William Herrick is shown observing Route 31 being paved from the front sidewalk of his home. This photograph, taken in the 1940s, shows the old Grange hall in the background. (Photograph by Clarence Hughson.)

Horse-drawn carriages were a common method of transportation before the advent of the automobile. Carriages were pulled by one, two, or four horses. The carriages in this photograph were traveling on the plank road. The plank road ran from Syracuse to Central Square on what later became Route 11. There were four tollhouses along the way, in Mattydale, at Pine Grove Road, in Cicero north of the four corners, and in Central Square. By 1913, the planks were removed along the entire route, and it was paved with macadam in 1914. By that time, one was more likely to see an automobile on Route 11 than a horse-drawn carriage.

This early school bus was photographed taking Mud Mill School (District 4) children to Cicero Union School in 1911. The bus was driven by Wilber Falter.

The Syracuse and Cicero Express carried merchandise between Syracuse and Central Square. Here George Busson is shown in front of Bitz's store.

Later the Syracuse and Cicero Express became motorized. Evan Fuller and his wife operated the express, which ran from Syracuse to Central Square every two weeks.

Clayton Eastwood founded the first school bus service in Cicero in 1931. He purchased this brand-new Dodge bus at a cost of $2,250. Before the 16 districts in Cicero were consolidated, it became necessary to transport some children to less-crowded schoolhouses. After the schools were centralized in the early 1950s, school bus transportation became a necessity.

Cicero was long known as a destination for Syracuse residents who wanted to go for a drive. In the days before the automobile, people drove their buggies to Cicero, had a meal at one of the local hotels, and drove home. By 1918, Cicero catered to the automobile crowd and was known as "the automobile showroom of Central New York." According to a 1918 newspaper article, at that time "the industry of the town" was gasoline. This Standard Oil truck may have been delivering gasoline to one of Cicero's many gas stations.

The advent of the electric trolley brought a quick end to the Cicero stage. However, the trolley's own existence was limited due to the increasing popularity of the automobile. The electric trolley served Cicero for less than 25 years. There were two lines. The first ran from Syracuse to Oneida Lake along South Bay Road. This line opened in 1908 and served the numerous resorts on the shores of Oneida Lake. It terminated at the lake where passengers could disembark for local hotels or board a steamship for an excursion to Frenchman's Island, Sylvan Beach, or other points on the lake.

The second trolley line ran parallel to Route 11, north to Cicero and Brewerton, and branched off the South Bay line at North Syracuse. This line opened in 1912. The trolley enabled Cicero residents to travel to Syracuse in minutes rather than hours for the first time. However, the automobile was being introduced to the masses at the same time, and soon the trolley was displaced as the preferred means of travel. Both lines were discontinued by 1932.

Although the trolley was a modern contrivance, the tracks were constructed using old-fashioned technology: a horse and wagon.

In this photograph from 1918 near Brewerton, the trolley demonstrates that inclement weather was no obstacle. Special trains equipped with plows kept the tracks clear.

The trolley was not trouble free, as revealed by this undated photograph showing damage from an accident. In 1920, a crash between two trolleys caused the death of the motorman, Harry Woodward.

The Airport Diner, long a fixture in Cicero, was torn down sometime after this 1987 photograph. It was located on Route 11, three quarters of a mile north of Route 31. The diner sat in front of the Cicero Airport, later known as Michaels Field.

Hayes Aviation, Inc,

SYRACUSE, N. Y.

Instruction Sales Transportation

This certifies that

Mildred Isbell (Oct.13, 1929)

Has had a flight in one of our airplanes

N⁰ 1316

Robt. C. Hayes
President

The Cicero Airport dates back to at least 1929. It was originally known as the Hayes Airport. This ticket is from Mildred Isbell Slinde's scrapbook, where she wrote, "First airplane ride & last."

Five

RURAL SCHOOLS

At one time, there were 16 rural district schools in Cicero. In 1949, Cicero schools became part of the North Syracuse School District. In 1951, Cicero Elementary School opened, and the 16 rural schools closed. This is the earliest photograph of the Cicero Union School, dating from 1876. In the 19th century, Cicero was poor and rural, as exemplified by the lack of shoes and tattered clothes of many of the students pictured here.

The Moulton School (District 2) was located on the southeast corner of Sneller Road and Route 11, about two miles north of the four corners. It was built in 1881 and was used until the district was centralized in the 1950s. During the 1934–1935 school year, there were 21 children in attendance. The 1975 photograph below captures the demolition of the school.

The (District 3) Cicero Union School was the largest of the approximately 16 one-room schoolhouses that dotted the town of Cicero's landscape. Built in 1867, it still stands on the southwest corner of Routes 11 and 31. This photograph is from 1886. It was actually a two-room schoolhouse, with the younger students on the first floor and upperclassmen on the second floor. It was used as a schoolhouse until 1920.

This photograph was taken in front of the Cicero Union School in 1890. The finery suggests a very special event, but the trees are too leafy for it to be Easter time.

The Universalist church and Cicero Union School were captured by this photograph around 1905. The Universalist church lasted until 1960, when it was razed.

This building ceased being a school in 1920 when a new schoolhouse was built north of the four corners. The building then became home to the Odd Fellows. After World War II, the Odd Fellows deeded the property to the American Legion, and it became the headquarters for the James T. Spire Post No. 787. Here a large military band is playing at an event in the 1940s. (Photograph by Clarence Hughson.)

The American Legion used the property until the mid-1990s. Legion business was conducted upstairs, and that space was also rented out for parties. By 1961, new, shorter windows were installed and the arches were bricked in. The first floor was raised, necessitating steps leading to the first floor, and a fire escape was added to the south side of the building. The belfry was removed when the building ceased being used as a school.

The building underwent a full restoration between 2004 and 2008 and is now being adaptively reused. The windows, chimneys, belfry, and entrance were restored to their original specifications, and the fire escape was moved to the rear of the building.

In 1922, the new Cicero Union School replaced the original one. This new school was on the east side of Route 31 just north of the intersection with Route 11. Unlike the building it replaced, this school had electricity, indoor plumbing, and was not heated by a parlor stove. After the centralization of the schools, the building was no longer used, and it was offered for auction in 1961. The building and one and a half acres of land were purchased by the Methodist Church for $13,000.

The Mud Mill School (District 4) was built in 1851 and was located on Mud Mill Road near Lakeshore Road. It was replaced in 1921 by the new schoolhouse shown above. This building was decommissioned as a schoolhouse in 1950 and has been used as a residence since then.

The Griffen School (District 5) was built on Route 31 at the east end of Bull Street. In the 1970s, it was known as Ye Old Schoolhouse Beauty Shop. It has been used as a residence for many years.

The Stone Arabia School (District 6) was built in 1854 on Route 31 just east of South Bay Road. It was operated continuously as a school for almost 100 years. The members of the class of 1946 pictured above from left to right are (first row) Junior Boyke, Robert Collen, Locket Henderich, Eddie Houde, Marilyn Collins, Phylis Hales, Richard Wellington, Beverly Hunter, Roger Chandler, Frances Houde, Jerry Williams, and Richard Schader; (second row) Bob Fuller, June Boyke, Diane Chandler, Teresa Dudzinski, Marjorie Chandler, teacher Dorothy Smith, Deanna Bristol, Bobby Sweeney, Billy Williams, Raymond Schader, and Beverly Russo.

The Pine Grove School (District 7) was built in 1827. It was located on the corner of Route 11 and Pine Grove Road. In 1925, it was replaced by a new schoolhouse. The new school, pictured below, had a basement, a furnace, and electricity, features the original schoolhouse lacked.

The original Cobblestone School (District 8), above, was constructed in 1842 with cobblestones. It was also known as George Washington School. In 1925, the cobblestone building was replaced at a cost of $10,000 with the building pictured below. The photograph below shows the new school, which was built in 1925 at a cost of $10,000. The second Cobblestone School still exists as a private residence on the corner of Thompson and Pine Grove Roads.

Taft Settlement School (District 9) was built in 1836. It was located on the south side of Taft Road opposite Kreischer Drive. The original schoolhouse blew down in 1908 and was rebuilt in 1909. The building was destroyed in 1942 during the construction of the Hancock air base.

The Taft Road School (District 10), built in 1843, was also known as Empire School. A student at the school, Lee Stevenson, allegedly saw a younger child being whipped with a ruler, so he hid the ruler. A school trustee discovered the ruler under the stone wall of the building 30 years later. The building still exists as a private residence at 6877 East Taft Road.

The Maple Bay School (District 12) was located on Route 31 between Lakeshore and Tuttle Roads. Some of the family names associated with this school are Tuttle, Pallas, Fielding, Crans, Dennis, Van Allen, and Moorehead.

The Conway School (District 13) was located on the corner of Taft and Totman Roads. It was built in 1853 and was used as a schoolhouse until 1945. A storage facility was built on the schoolhouse site.

The Mud Mill School (District 14) was located on the west side of Route 11 at the intersection with Mud Mill Road. A Baptist church was later built on the site. The children in this photograph include Wesley Moorehead, Frank Horner, Esther Kenyon, Folger Graves, Frances Graves, Charles Watkins, Clarence Brown, Edna Ladd, Verneta Watkins, Esther Brayton, and Chester Horner.

Cicero Center School (District 15) was built in 1883. The above photograph is undated but was taken by George Crans. He was a railroad mail clerk who owned the first camera in the area.

The above photograph depicts the Cicero Center School class of 1885. The children had to go to Bridgeport to pose for this photograph, which was taken in a tent. The photograph below shows the interior of the school.

Six

OUTSIDE THE
FOUR CORNERS

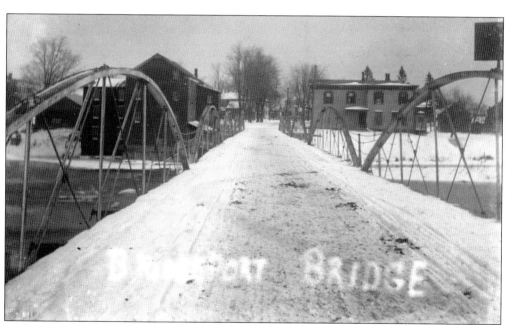

Bridgeport, South Bay, and Brewerton flourished prior to the 20th century. Bridgeport is marked by a large bridge that passes over the Chittenango Creek. It was here that Samuel de Champlain crossed the rapids in 1615. The hamlet of Bridgeport is split at the bridge between Onondaga and Madison Counties, and this photograph was taken from the Cicero side looking toward Madison County. Bridgeport was a busy manufacturing community in the 19th century. The Cicero side of Bridgeport was home to a sawmill, a tannery, a broom factory, and a match factory.

Born in 1852, George Crownhart ran numerous hotels in the Cicero and South Bay area, including the Parker House (later King's Hotel). He built Crownhart's Hotel on Oneida Lake at South Bay. Crownhart's Hotel was the premier destination for visitors to the South Shore of Oneida Lake. Guests disembarked from the electric trolley terminus at the end of South Bay Road and strolled down a boardwalk a short distance to the hotel. During this era, South Bay was known as the "Atlantic City of Oneida Lake."

The Anglers Club building was originally known as the Sagamore Inn. It was built on the shore of Oneida Lake about one mile west of the present Lakeshore Country Club. The Sagamore was a failed venture and was purchased by the Anglers Club in 1908. The club invested heavily in the building; however, it burned to the ground later that year.

After the Anglers Club building burned in 1908, the members decided to purchase Norcross Point and were determined to have a more fire-resistant club. The Lakeshore Country Club now occupies the building.

Wells Park was located east of the new Anglers Club on the shores of Oneida Lake. The park was built on the site of the Wells Park Hotel. The Wells Park Hotel, along with Crownhart's Hotel, the Sagamore (later the Anglers Club), and Therre's were the resorts that attracted day travelers and vacationers alike to South Bay. The hotel burned to the ground on February 7, 1914. This location later became the site of Borio's restaurant. (Photograph by Clarence Hughson.)

Therre's Restaurant and Skating Rink
Bay Road, Oneida Lake
South Bay, N. Y.

Therre's pavilion was a popular location for dancing, dining, and roller-skating. It was located on Lakeshore Road at South Bay on Oneida Lake. The Therre family also ran a hotel/restaurant and boat livery. The property was later used for boat storage. It was destroyed by fire on December 23, 1961.

ROLLER SKATING
THERRE'S
SOUTH BAY

STARTING

SATURDAY, APRIL 16, 1949

EVERY WEDNESDAY, SATURDAY
And SUNDAY Afternoon and Evening

Frenchman's Island is located in the middle of Oneida Lake. The island was reputedly named after a French noble and his child bride who occupied the island at the dawn of the 18th century. In the latter part of the 19th century, there was a succession of hotels on the island; however, by the mid-1900s, there were no structures left. For a time, Frenchman's Island was owned by the Syracuse Northern Electric Railway. The trolley line terminated at South Bay on the shores of Oneida Lake. From there, passengers could take a railway-owned steamer to the island or around the lake.

The trolley proceeded up modern-day South Bay Road, through an underpass that crossed Lakeshore Road, and stopped at the trolley turnaround at the end of South Bay Road. Here steamers transported the trolley riders to Frenchman's Island and other sites on Oneida Lake for a day (or week) of fun in the sun.

Dock at South Bay N.Y.

Bird's-eye View, Brewerton, N. Y.

This photograph provides a view of Brewerton looking north along Route 11. It was taken from the steeple of the Disciples of Christ Church (1851–1920) in 1899. The old Brewerton Bridge is visible in the background.

The Disciples of Christ Church was the oldest religious organization in Brewerton. This church was built in 1851 on the east side of Route 11 between Kathan Road and Washington Street. The tall steeple was struck by lightning three times during its existence, finally resulting in the building's demise on November 23, 1920. The church was rebuilt on the same site out of cobblestones from the Oneida River.

The Washburn House was built in 1871 by Charles E. Washburn at a cost of $ 20,000. It stood on the southwest corner of Bennett Street and Route 11. For over 100 years, it served as the center of activity for Brewerton. In the 1970s, it was known as the Village Inn. It was razed after a small fire in which a woman perished. The photograph below was taken around 1940 from the second floor of the hotel (known as Gill's Hotel at the time) looking south down Route 11.

Main Street, looking South, Brewerton, N. Y.

This view from about 1900 looking south from near the Brewerton Bridge is not much different today. The Main Street business district is largely intact. The large steeple of the Disciples of Christ Church is visible on the left. The church building burned in 1920 and was rebuilt with cobblestones.

DEPOT ST. BREWERTON, N.Y.

No reference can be found of Depot Street in Brewerton anywhere except on this postcard. This photograph was likely taken from the intersection of Route 11 (sometimes known as State Street) looking west down Railroad Street (now known as Library Street). It appears that the train depot is visible at the end of the street.

The River Side House was located on the corner of Walnut and Bennett Streets. The hotel was formerly a private house and was then operated as a boardinghouse from 1884 until about 1900. The original structure was moved, and a new house was built on the site in 1907. The new house was later turned into a hotel known as River Side House.

This graded school was built in 1892. It was located near the site of the present Brewerton Fire Department and was used as a schoolhouse until 1950. It was subsequently purchased by the Brewerton Fire Department and used for storage. Later one room was occupied by the Brewerton Free Library. It was razed the late 1950s.

The trolley line between Syracuse and Cicero began in 1908. The six-mile stretch between Cicero and Brewerton was opened in 1912. In addition to passengers, the trolley was also used to transport ice cut from Oneida Lake. The trolley was in operation until 1932.

Seven

THE COMMUNITY

During the 19th and early 20th centuries, there were many clubs and organizations to join in Cicero. Men could join the volunteer fire department (shown here), the Grange, the Odd Fellows, or the American Legion. Women could be members of the fire department or American Legion ladies auxiliaries, the Utopia Club, the Rebekahs, or the Alethean Club. Boys could be involved in Boy Scouts and girls in Camp Fire Girls or Girl Scouts. (Photograph by Clarence Hughson.)

The Cicero Volunteer Fire Department has been in existence since 1897, although the first organized fire protection began in 1883. The old fire barn, built in 1923, was located on the northwest corner of Routes 11 and 31. It was replaced by a more modern building in 1956. The Cicero Ladies Auxiliary, pictured above and below, provided much-needed support for the all-volunteer fire department. The auxiliary is still in existence today.

By today's standards, the games being played at the Cicero Fireman's Field Days in the 1940s would pose an unnecessary exposure to liability. In the above photograph, the firemen are standing on rickety scaffolding while dumping a large, heavy drum of water onto the people below. In the photograph below, the object of the game appears to be hitting one's opponent in the face with a high-pressure burst of water. (Photographs by Clarence Hughson.)

B. J. Flynn (with cane) and Clarence Bitz are pictured in the 1940s. Flynn and Bitz were both business owners at the four corners. The businessmen and businesswomen at the four corners took on most of the responsibility of maintaining the community. Flynn was the fire chief from 1926 to 1938, and Bitz was chief from 1938 to 1948. Flynn's grandfather was Charles Bonstead. His son Kenneth was married to Lona Flynn, longtime Cicero town historian. The old fire barn, below, stood on the west side of Route 11 just in from Route 31. It was later replaced with the current firehouse. (Photographs by Clarence Hughson.)

The Odd Fellows and its auxiliary, the Rebekahs, were social groups that served their communities. Odd Fellows Lodge No. 907 was formed in Cicero in 1907, and Rebekah Lodge No. 504 was formed in 1913. Early membership rosters included many familiar names such as Shepard, Bitz, Klosheim, Eggleston, King, and Herrick. Both groups met in rooms on the second floor of Flynn's meat market. In 1923, the Odd Fellows purchased the original Cicero Union School, and both groups met there until the 1960s. The 17 remaining members of Odd Fellows Lodge No. 907 surrendered its charter in 1961, and the Cicero Rebekahs consolidated with the Liverpool Rebekahs in 1968.

The Camp Fire Girls of Cicero organized in 1914, four years after the national organization began. These girls, wearing the traditional Camp Fire ceremonial dress, are unidentified, but some of the early members were from families with familiar names, including Sayles, Herrick, Eggleston, and Potter. In the summers, some of the Cicero Camp Fire Girls attended camp on Oneida Lake in Cleveland.

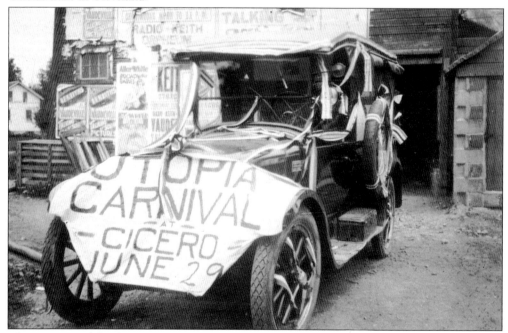

The Utopian Club of Cicero began on the steps of Lucy Black's home sometime around 1913. Some of the early members included Helen Potter, Lucy Sleeth, Bessie Bonstead, and Alice Plant. The purpose of the club as stated in its bylaws was "to give aid to worthy causes in the Community and the World, and to stimulate better social life to the members through various types of Programme." The club founded the library in Cicero.

122

For decades, American Legion James Harvey Spire Post 787 has organized the annual Memorial Day parade. That parade, commemorating the sacrifice of veterans, follows a route from the American Legion to the Cicero cemetery. In addition to the Memorial Day parade, many community groups and schoolchildren, such as those pictured above in front of King's Hotel, have participated in parades down Route 11.

N. SYRACUSE LEAGUE
J. WINTERSDORF~G. HILL~C. HAEFNER~R. SHOULTES~W. SCHULTZ~F. ZAHN

These bowlers from the North Syracuse League were sponsored by King's Hotel. Many bowling banquets were held at King's Hotel and at the American Legion nearby. In the 1880s, there was an early bowling alley that was part of the Ocean House hotel located on Norcross Point, the later site of Lakeshore Country Club. The hotel burned in 1882, but the bowling alley was not damaged and was used for several years.

In the 1890s, the invention of the modern, pneumatic-tubed bicycle caused a biking craze to sweep America. Charles King was quoted as saying in 1930, "When the old plank road was in use, bicycles became so numerous horses seemed to be as scarce as they are today. I had racks on both sides of the road for the bikes." Bicycle races where held every Sunday morning during the spring and summer. Contestants raced from the Syracuse city line to Cicero and back again. In these photographs, the planks in the road are clearly visible. Howard Coonley was the winner of this race. Bicycling was so popular that in 1897, a four-foot-wide cinder path was created that started at the four corners and extended on the north side of Lakeshore Road all the way to South Bay.

By the dawn of the 20th century, baseball was a popular pastime in America. The American League was formed in 1900, the first World Series was played in 1903, and the first baseball stadiums were being built. Baseball provided entertainment for adults and children alike in rural America. Many small towns had their own baseball leagues, and Cicero was no exception. The above photograph is of the Cicero Center baseball team. The team in the photograph below is identified as a Cicero team.

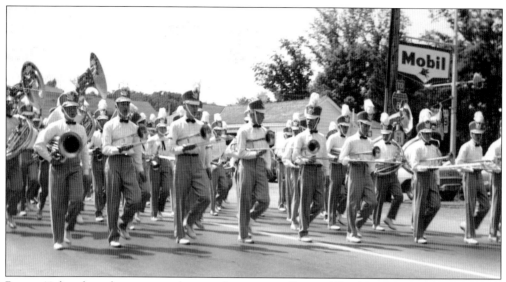

Route 11 has long been a popular parade route in Cicero. The North Syracuse Band was photographed marching in the 1962 Cicero Memorial Day parade. In the background is the Hines Mobil gasoline station at the four corners. Firefighters, members of the American Legion, Girl and Boy Scouts, and many local businesses, clubs, and elected officials continue to take part in the annual parades through Cicero.

The men in this 1930s photograph were members of the American Legion James Harvey Spire Post 787. Included are Anthony Mancena, Dr. William Winne, Peter "Bill" Herbrandt, Cyle Dolbear, Herbert Palmer, Maurice Roe, Herbert Miller, J. Harold Klosheim, Fred West, Ernest Fisher, and Wells H. Andrews. Post 787 was chartered in 1920, and in 1948, the Odd Fellows gave its building to the legion. In 2003, the legion broke ground for a new building off Route 31 behind the post office.

CICERO COMMUNITY HONOR ROLL

WILLIAM BEARUP	NORMAN DIFFIN	NORMAN MASSET	ALEXANDER SIKORA
ARTHUR BEDET	HAROLD EGGLESTON	JOHN MASSETT	ROY SMILEY JR.
DONALD BITZ	KENNETH EDWARDS	WILLIAM MEADER	WILLIAM B SMITH
JACK BITZ	KENNETH FLYNN	STEWART MINER	AUGUSTUS THERRE
PETER BLEICH	FRANCIS FREEBERN	RICHARD NORTHRUP JR	DONALD THERRE
WILLIAM BLEICH	ANTHONY ORAZIO	WM. PARKHURST	EDWARD BOYKE
FREDERICK BRANDT	PAUL GREEN	JOHN PAWELEK	PAUL F STEVENS
DOUGLAS A.BROWN	GILBERT OOKEY	PERRY PARSONS	PAUL LOUGHNUT
ANDREW BOYKE	LAWRENCE GONYA	JOSEPH PISANI	ROBERT WESTON
CHARLES BRAUCHLIE	DONALD HAMMOND	CECIL POST	LEROY WIBORN
DOUGLAS BURTON	FRED HENNESSY	WARD V. RUSSELL	FRANK WILLIAMS, M.D.
	JACK HILLENBRANDT	FLOYD SERVISS	KENNETH WRIGHT
ROBERT CAMPBELL	NORMAN HOUSE	ROBERT SHEPARD	PAUL WARNER JR
ROBERT CHAPMAN	LYMAN HOWE	KENNETH SHEPARD	JOHN WEAVER
PHILLIP CLARK	REGINALD JONES	HOMER GHEPARD	FRED WEATHERLY
FRANCIS CURTIS	ARCHIE THOMAS	JACK SHORTER	FRANKLIN WILLIAMS
	ROBERT BOYKE	CHESTER SIKORA	EDWARD ZEPP
	NORMAN C. BULLETT	MITCHELL SIKORA	STANLEY ZEPP

7

In 1943, the Cicero firemen and ladies auxiliary, the Alethean and Utopian Clubs, and the library guild sponsored this plaque in honor of the boys and men of Cicero who were serving their country. By July of that year, the sponsors collected 55 names and continued to solicit more. The plaque was erected on the site of the original Cicero Union School, which then housed the Odd Fellows. The plaque disappeared a short time later when Route 11 was widened. (Photograph by Clarence Hughson.)

ACROSS AMERICA, PEOPLE ARE DISCOVERING
SOMETHING WONDERFUL. THEIR HERITAGE.

Arcadia Publishing is the leading local history publisher in the United States. With more than 3,000 titles in print and hundreds of new titles released every year, Arcadia has extensive specialized experience chronicling the history of communities and celebrating America's hidden stories, bringing to life the people, places, and events from the past. To discover the history of other communities across the nation, please visit:

www.arcadiapublishing.com

Customized search tools allow you to find regional history books about the town where you grew up, the cities where your friends and family live, the town where your parents met, or even that retirement spot you've been dreaming about.

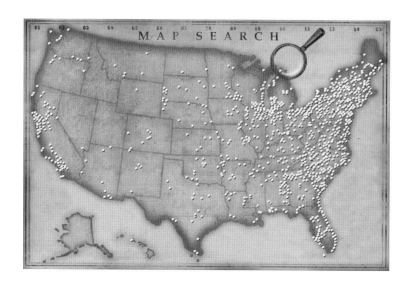